Grandmother's Book

BY
MARCIA O. LEVIN

CRESCENT BOOKS

NEW YORK

ILLUSTRATIONS

James Jabusa Shannon
JUNGLE TALES
1895
oil on canvas
34¾ × 44¾"
The Metropolitan Museum of Art, New York
Arthur Hoppock Hearn Fund, 1913

Anonymous
BIRTH AND BAPTISMAL CERTIFICATE OF ANNE ANDRES
c. 1783
pen and iron gall ink with watercolor on laid paper
13¼ × 16"
National Gallery of Art, Washington, D.C.
Gift of Edgar William and Bernice Chrysler Garbisch

Joseph H. Davis
JOHN AND ABIGAIL MONTGOMERY
1836
pen and watercolor
8⅞ × 14"
National Gallery of Art, Washington, D.C.
Gift of Edgar William and Bernice Chrysler Garbisch

Edouard Vuillard
THEODORE DURET
1912
cardboard mounted on wood
37½ × 29½"
National Gallery of Art, Washington, D.C.
Chester Dale Collection

Carl Schaefer
ONTARIO FARM HOUSE
1934
oil on canvas
42 × 49⅛"
National Gallery of Canada, Ottawa
Gift of Floyd S. Chalmers, Toronto, 1969
Reproduced by permission of the artist

Winslow Homer
HOMEWORK
1874
watercolor
8 × 5"
Canajoharie Library and Art Gallery, New York

Frank W. Benson
PORTRAIT OF MY DAUGHTERS
1907
oil on canvas
26⅛ × 36⅛"
Worcester Art Museum, Massachusetts

Norman Rockwell
STORYTELLER
1945
oil on canvas
46 × 42"
The Norman Rockwell Museum at Stockbridge, Massachusetts
Printed by permission of the Estate of Norman Rockwell
Copyright © 1945, Estate of Norman Rockwell

Mary Cassatt
ALEXANDER CASSATT AND HIS SON ROBERT
1884–85
oil on canvas
39 × 32"
Philadelphia Museum of Art
W. P. Wilstach Collection

Grandma Moses
A COUNTRY WEDDING
1951
oil on Masonite
17 × 22"
Copyright © 1973, Grandma Moses Properties Co., New York

Norman Rockwell
FREEDOM FROM FEAR
1943
oil on canvas
45¾ × 35½"
The Norman Rockwell Museum at Stockbridge, Massachusetts
Printed by permission of the Estate of Norman Rockwell
Copyright © 1943, Estate of Norman Rockwell

Norman Rockwell
FAMILY TREE
1959
oil on canvas
46 × 42"
The Norman Rockwell Museum at Stockbridge, Massachusetts
Printed by permission of the Estate of Norman Rockwell
Copyright © 1959, Estate of Norman Rockwell

Grandma Moses
ROCKABYE
1957
oil on Masonite
11⅞ × 16"
Private collection
Copyright © 1973, Grandma Moses Properties Co., New York

Wayne Thiebaud
BUFFET
1972–75
oil on canvas
48 × 60"
Private collection
Courtesy Allan Stone Gallery, New York

Norman Rockwell
FREEDOM FROM WANT
1943
oil on canvas
45¾ × 35½"
Printed by permission of the Estate of Norman Rockwell
Copyright © 1943, Estate of Norman Rockwell

Picture research: Ann Levy

Calligraphy: Gunta Alexander

This 1992 edition published by CRESCENT BOOKS
distributed by Outlet Book Company, Inc.,
a Random House Company, 225 Park Avenue South
New York, New York 10003.

Printed and Bound in Hong Kong

ISBN 0-517-07009-X

8 7 6 5 4 3 2

Dedication

This is a book of memories
lovingly recorded by

and given to

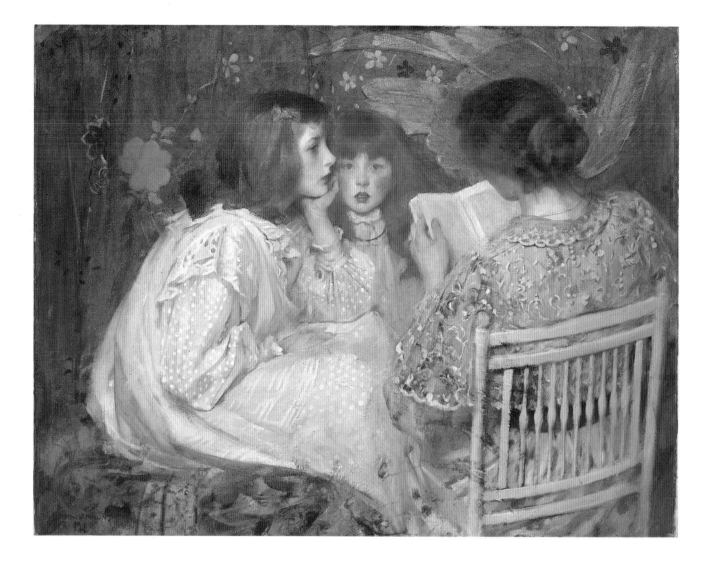

JUNGLE TALES—*James Jabusa Shannon*

Prologue

 This book was written especially for you.
It has been a joy for me to recall my childhood
and later years and to share them with you.
There is much here, also, about other members
of your family.

 Perhaps some day, when you yourself
are a grandparent, you will have a book like
this for your own grandchildren, who will be
as dear to you as you are to me.

Here is what I looked like
when I filled out this book.

Paste
a recent
picture
of yourself
here.

Date_____

The name you always call me is

Backward, turn backward, O Time, in your flight,
Make me a child again just for tonight.

~ Elizabeth Allen (1832-1911)

Paste
a childhood
picture
of yourself
here.

This is the earliest picture of me.
I was ____ years old.

My full name is _____

I was named that because _____

The date of my birth was _____

The place of my birth was _____

Other things you might like to know about my birth.

BIRTH AND BAPTISMAL CERTIFICATE OF ANNE ANDRES—Anonymous

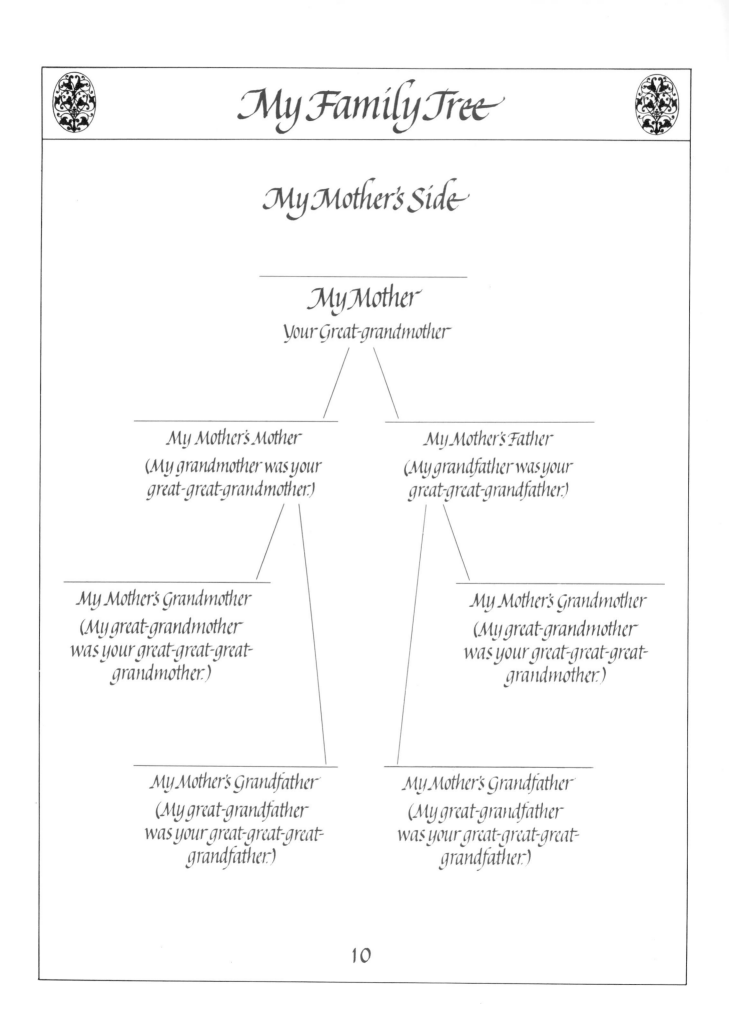

My Mother's Side

My Mother
Your Great-grandmother

My Mother's Mother
(My grandmother was your
great-great-grandmother.)

My Mother's Father
(My grandfather was your
great-great-grandfather.)

My Mother's Grandmother
(My great-grandmother
was your great-great-great-
grandmother.)

My Mother's Grandmother
(My great-grandmother
was your great-great-great-
grandmother.)

My Mother's Grandfather
(My great-grandfather
was your great-great-great-
grandfather.)

My Mother's Grandfather
(My great-grandfather
was your great-great-great-
grandfather.)

My Father's Side

My Father
Your Great-grandfather

My Father's Mother
(My grandmother was your
great-great-grandmother.)

My Father's Father
(My grandfather was your
great-great-grandfather.)

My Father's Grandmother
(My great-grandmother
was your great-great-great-
grandmother.)

My Father's Grandmother
(My great-grandmother
was your great-great-great-
grandmother.)

My Father's Grandfather
(My great-grandfather
was your great-great-great-
grandfather.)

My Father's Grandfather
(My great-grandfather
was your great-great-great-
grandfather.)

My Grandparents

*It is indeed desirable to be well descended,
but glory belongs to our ancestors.* —Plutarch (46-120 A.D.)

My mother's mother's birth place was _____
 Her birth date was _____
My mother's father's birth place was _____
 His birth date was _____
Where they lived when I knew them _____
What I remember best about them is _____

My father's mother's birth place was _____
 Her birth date was _____
My father's father's birth place was _____
 His birth date was _____
Where they lived when I knew them _____
What I remember best about them is _____

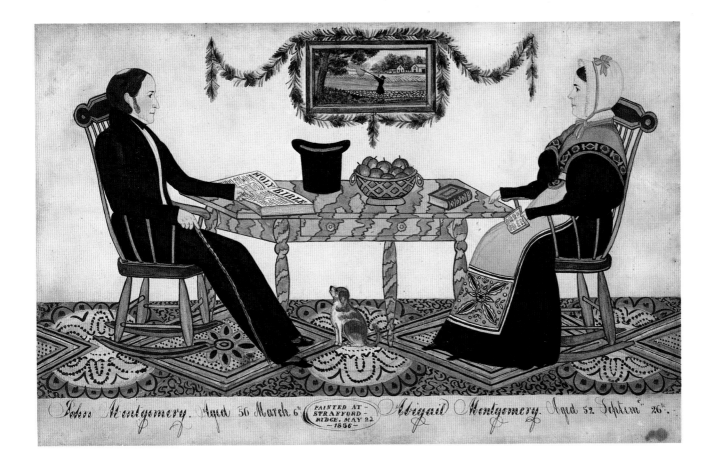

JOHN AND ABIGAIL MONTGOMERY—*Joseph H. Davis*

My Parents

Who ran to help me when I fell,
And would some pretty story tell,
Or kiss the place to make it well?
My mother. —*Ann Taylor (1782-1866)*

My mother's full name was _____

 Her birth place _____

 Her birth date _____

 Her education and occupation were _____

My father's full name was _____

 His birth place _____

 His birth date _____

 His education and occupation were _____

Their marriage took place in _____

 on _____

Where they lived _____

My Mother

Here are some things I would like you to know
about my mother.

One father is more than a hundred schoolmasters.

—George Herbert (1593-1633)

Here are some things I would like you to know about my father.

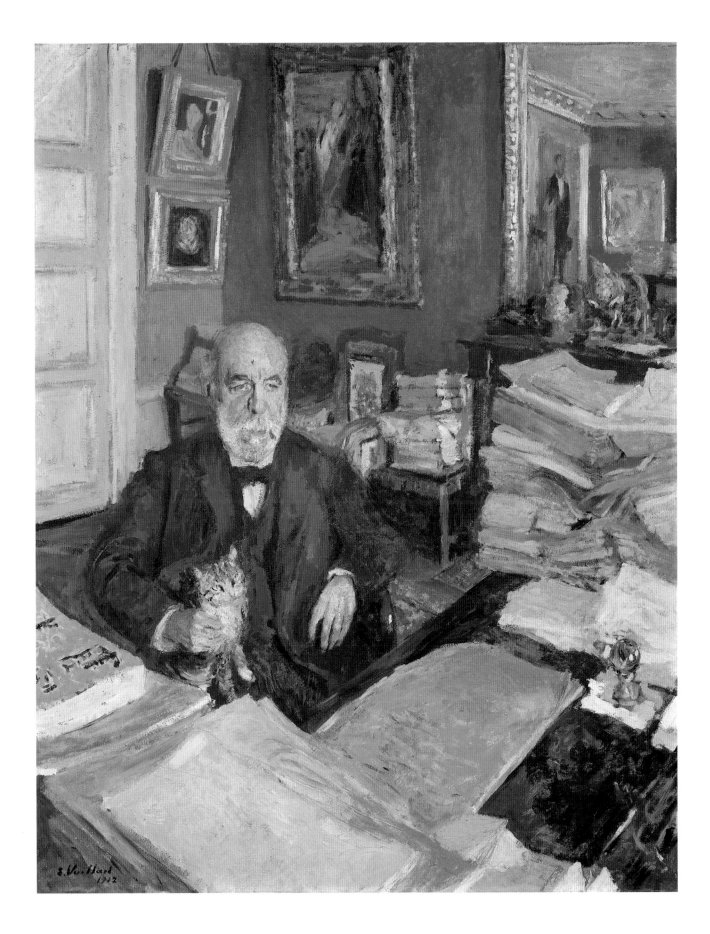

THEODORE DURET—Edouard Vuillard

These are my sisters, brothers and other
relatives who have been important to me.

Name _____

Relationship to me _____

Name _____

Relationship to me _____

Name _____

Relationship to me _____

Name _____

Relationship to me _____

Name _____

Relationship to me _____

Name _____

Relationship to me _____

Name _____

Relationship to me _____

Name _____

Relationship to me _____

Name _____

Relationship to me _____

I remember, I remember
The house where I was born,
The little window where the sun
Came peeping in at morn.

—Thomas Hood (1799-1845)

The home where I lived as a child was in _____

I remember this about my home. _____

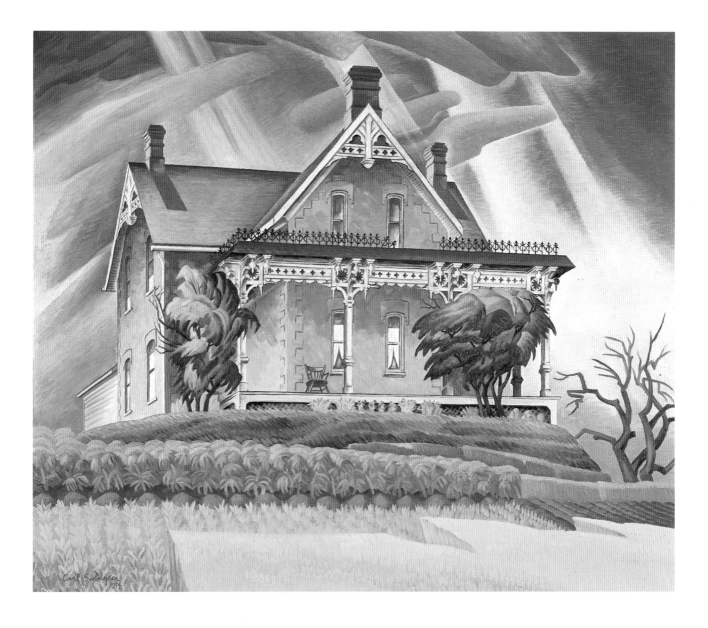

ONTARIO FARM HOUSE—Carl Schaefer

I have more memories than if I were a thousand years old.
—Baudelaire (1821-1867)

Can you remember things that happened when you were very, very small? I was once that small too, and here are a few things I remember from those days.

Even a child is renown by his doings, whether
his work be pure, and whether it be right.

—*Proverbs 20:11*

Here are a few of the funny, or clever, or unusual incidents in my early life that my parents enjoyed telling about.

My School Days

School days, school days,
Dear old Golden Rule days!

These are the schools I attended.

Name _____

Its location was _____

My most vivid memory is _____

Name _____

Its location was _____

My most vivid memory is _____

Name _____

Its location was _____

My most vivid memory is _____

24

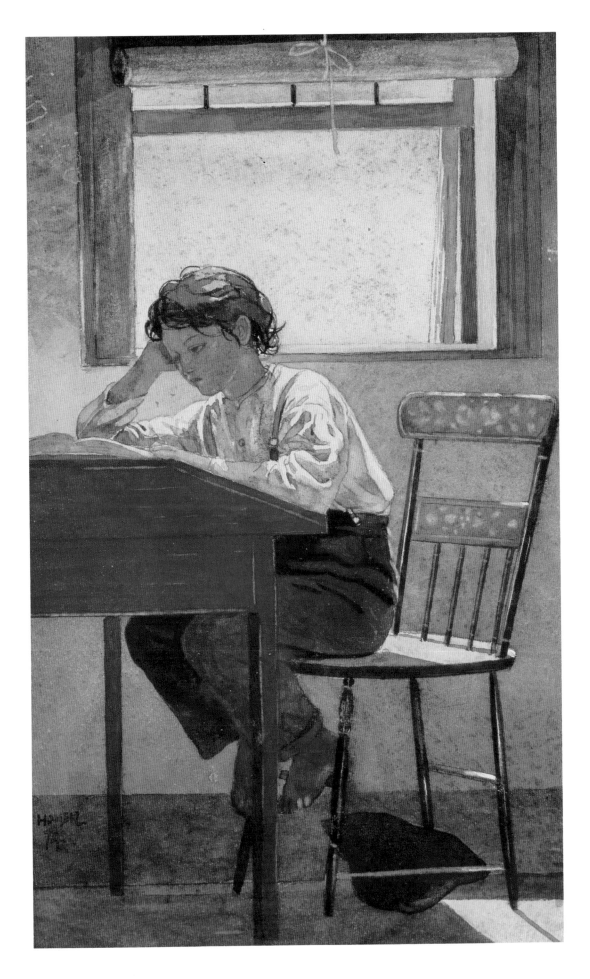

HOMEWORK—*Winslow Homer*

The days that make us happy make us wise.

~John Masefield (1878-1967)

The subject I liked most was _____

because _____

The subject I liked least was _____

because _____

My after-school activities were _____

My other interests included _____

I was proudest when _____

I have had playmates, I have had companions,
In my days of childhood, in my joyful school days.

— Charles Lamb (1775-1834)

My friends were _____

Our favorite meeting place was _____

Our pastimes included _____

The most fun we had was when _____

My very best friend was _____

because _____

Nothing endures but change —Heraclitus (540-480 B.C.)

When I was young the style of dress for girls was _____

The style of dress for boys was _____

The popular hairstyles were _____

Fashions and fads of the time included _____

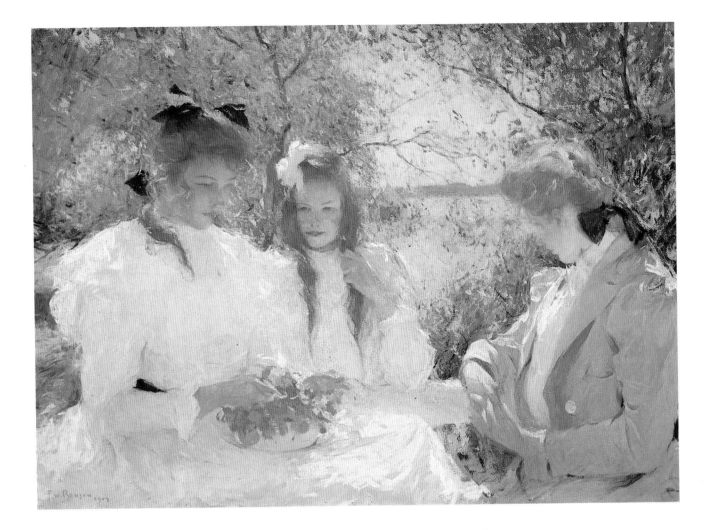

PORTRAIT OF MY DAUGHTERS—*Frank W. Benson*

The popular music was _____

Popular singers I liked most included _____

My favorite dances were _____

The inventions that appeared when I was young
included _____

The most exciting discoveries made in those days were _____

When the dog bites,
When the bee stings,
When I'm feeling sad,
I simply remember my favorite things,
And then I don't feel so bad.

– Oscar Hammerstein (1895-1960)

Family member _____

Teacher _____

Game _____

Hobby _____

Book _____

Entertainment _____

Holiday _____

Vacation _____

Foods _____

Pets _____

Certain events that occur while we are growing up remain memorable. Whether we were six years old or sixteen at the time, we can recall not only when they happened, but what we were doing when we heard the news. Here are a few of the events that left a lasting impression on me.

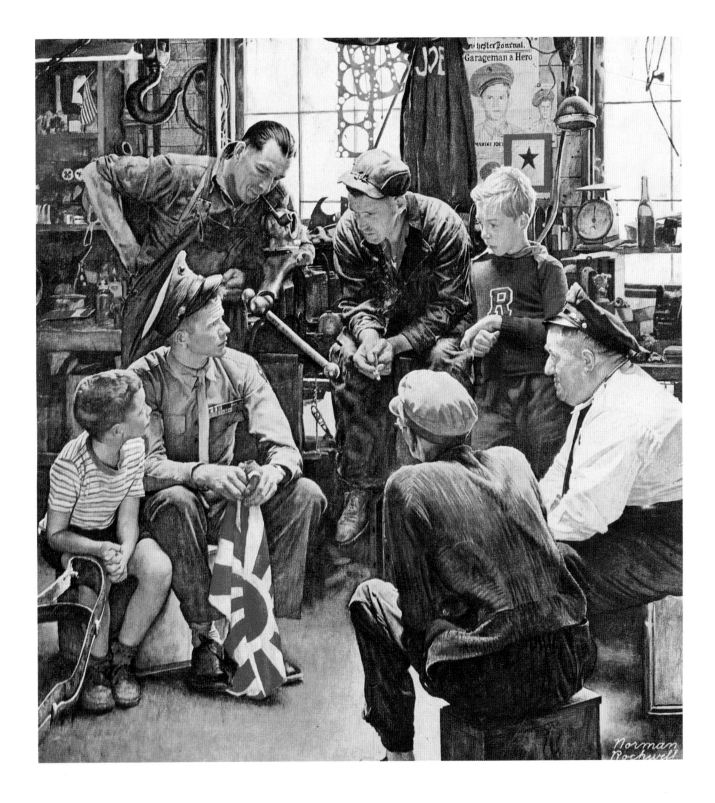

STORYTELLER—Norman Rockwell

Oh, talk not to me of a name great in story;
The days of our youth are the days of our glory.

—Lord Byron (1788–1824)

Your grandfather's full name was _____

The way we met was _____

Our ages when we met were _____

My first impression of him was _____

Our first real date was _____

Your Grandfather

Your grandfather was born in _____

His birth date was _____

The place where he grew up was _____

His parents were _____

Other things about his family were _____

Other things about his background and education were

As we began to know each other better, I learned
these things about the man I was going to marry.

His work was _____

His ambition was _____

The books he liked were _____

His favorite sport was _____

The foods he enjoyed were _____

The entertainment he preferred was _____

What I liked most about him was _____

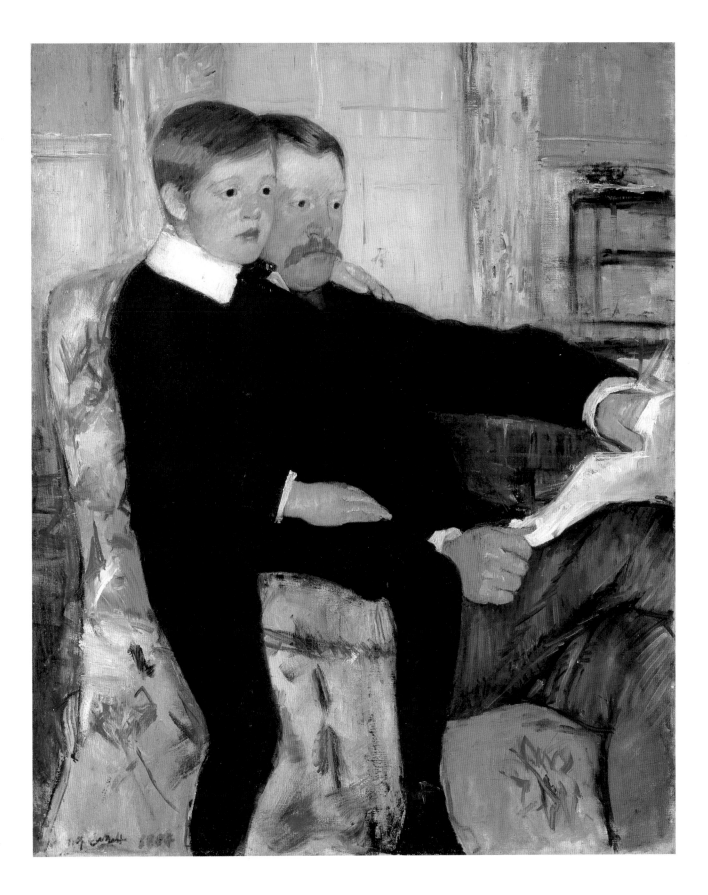

ALEXANDER CASSATT AND HIS SON ROBERT—*Mary Cassatt*

'My true love hath my heart, and I have his,
By just exchange one for the other given.
— Sir Philip Sidney (1554-1586)

We decided to get married after knowing each other _____

The way we told our families and friends was _____

The way we planned our wedding was _____

The date of our wedding was _____
The ceremony took place at _____

We invited relatives and friends, including _____

Wedding gifts I remember were _____

I wore _____

The groom wore _____

Our attendants were _____

The wedding meal was _____

My feeling that day was _____

Our Marriage

A woman's whole life is a history of the affections.
—Washington Irving (1783-1859)

On our honeymoon we went to _____

Our first home was _____

What I remember about our home is _____

The way I spent my days was _____

The way your grandfather spent his days was _____

Our first anniversary was _____

Our early challenges included _____

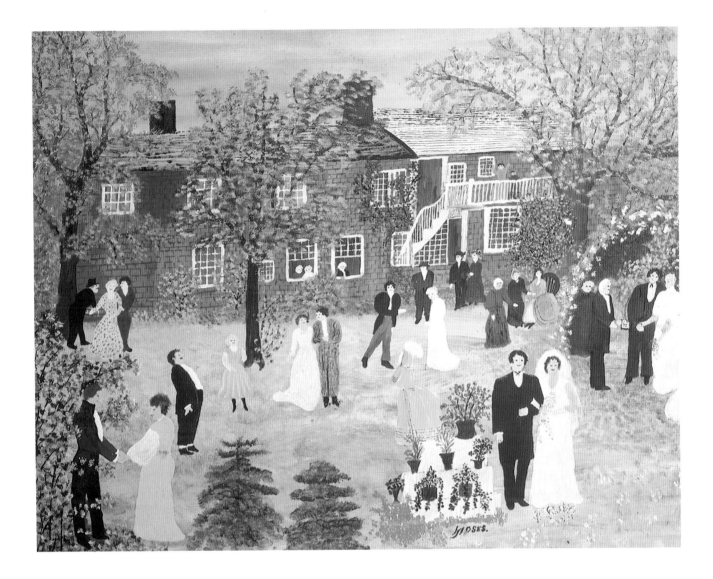

A COUNTRY WEDDING—Grandma Moses

Rock-a-bye baby, on the tree top.
When the wind blows, the cradle will rock.

—Charles Blake (1846-1903)

Some memories of my child, who grew up
to be your parent, include

Date of birth _____

Place of birth _____

We chose the name _____

The reason for the name was _____

First reactions to the baby included

What I said _____

What other people said _____

Time is but the stream I go a-fishing in.
—Henry David Thoreau (1817-1862)

It seems only yesterday that your parent was
a little child, learning about the world. I still recall
with fondness some of the things that happened then.

Your Parent

How beautiful is youth! How bright it gleams,
With its illusions, aspiration, dreams!
Book of beginnings, story without end,
Each maid a heroine, and each man a friend.

—Salutamus

Here are some of the things you might like to know about your parent's growing-up years.

Schools attended _____

Special abilities _____

Special interests _____

Hobbies _____

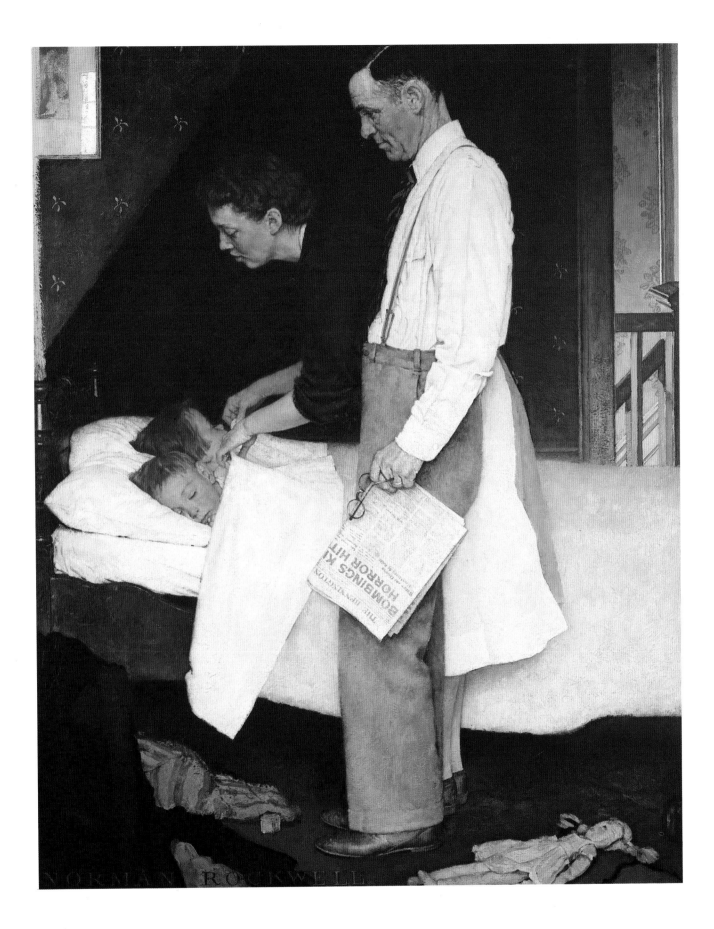

FREEDOM FROM FEAR—Norman Rockwell

The Way It Was

The more things change, the more they remain the same.
—French Proverb

When your parent was a teenager, this is what was happening:

The style of dress for girls was _____

The style of dress for boys was _____

Fashions and fads of that time were _____

The music that was popular was _____

Popular dances were _____

The inventions of the day included _____

The most exciting discoveries were _____

There's nothing half so sweet in life
As love's young dream. —Thomas Moore (1779-1852)

The place they met was _____

Their ages were _____

Our first meeting was _____

The place they were married was _____

The date of the ceremony was _____
My memories of that day include _____

You Are Born

Around the child tend all the three
Sweet Graces: Faith, Hope, Charity.
—Walter Savage Landor (1775-1864)

Your birthday was _____

You were born in _____

You weighed _____

You were named by _____

That name was chosen because _____

Other things I remember about your birth include _____

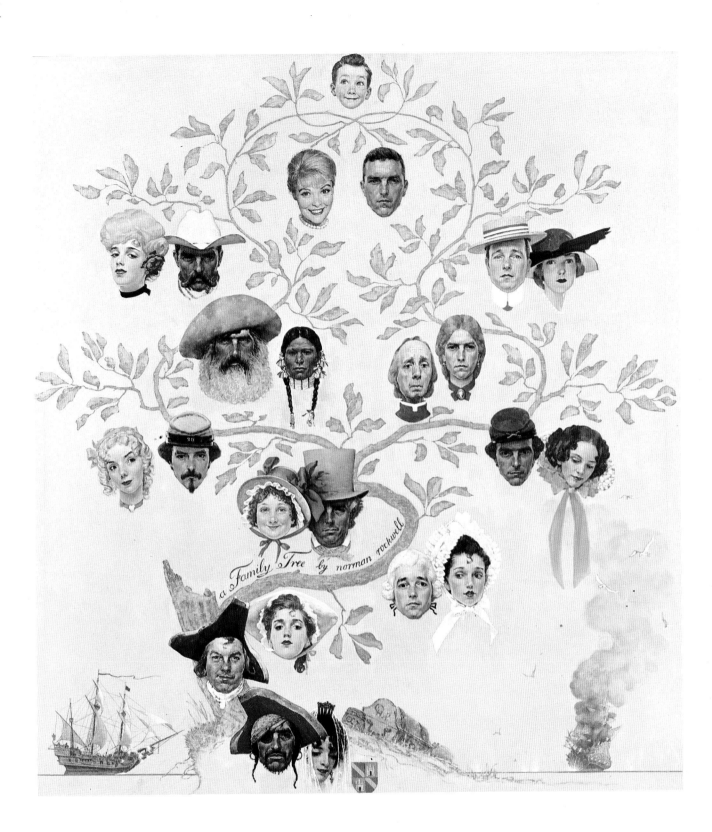

FAMILY TREE—Norman Rockwell

Life as Your Grandmother

Oft in the stilly night,
Ere Slumber's chain has bound me,
Fond Memory brings the light
Of other days around me. —Thomas Moore (1779-1852)

How delighted I was to hear that you had arrived! I couldn't wait to see you.

The place where I heard was _____

What I was doing was _____

I first saw you when _____

The first time I took care of you was _____

I remember you as the kind of baby who _____

Give a little love to a child, and you get a great deal back.
~John Ruskin (1819-1900)

The songs I sang to you were _____

Your favorite story was _____

The games we played included _____

Your favorite toys were _____

Your favorite gifts from me were _____

Your Visits to Me

The length of your stay was usually _____
You usually came with _____

Our favorite pastimes were _____

I think you liked my home because _____

I remember the time when you _____

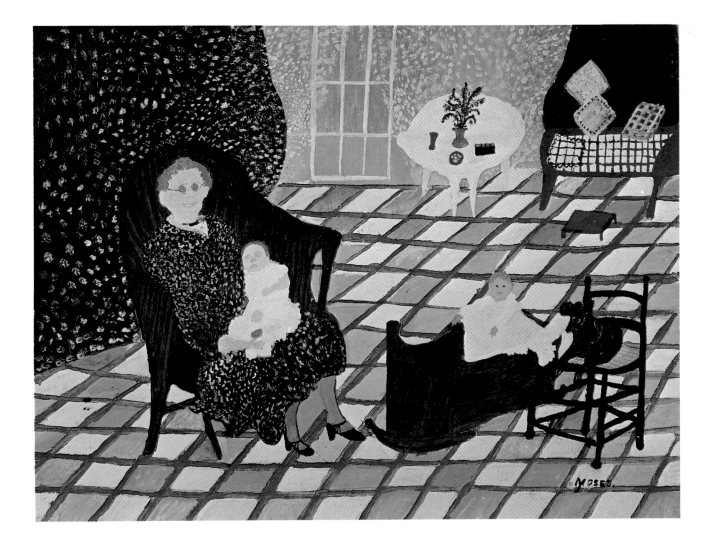

ROCKABYE—Grandma Moses

I remember a trip we took together.

The place we went was _____

The date of the trip was _____
The way we traveled was _____

With us was _____

My special memory of that trip is _____

Other places we went together were _____

Your favorite outing was _____

You Remember Grandmother

I have saved a page so that you can help me finish our book, for it should be yours as well as mine.

Your earliest memory of me is _____

Other things you remember include _____

My Favorites Now

Times change, and we change with them.
—Edmund Spenser (1552-1599)

Game _____

Hobby _____

Book _____

Movie _____

Television program _____

Holiday _____

Vacation _____

Friend _____

Foods _____

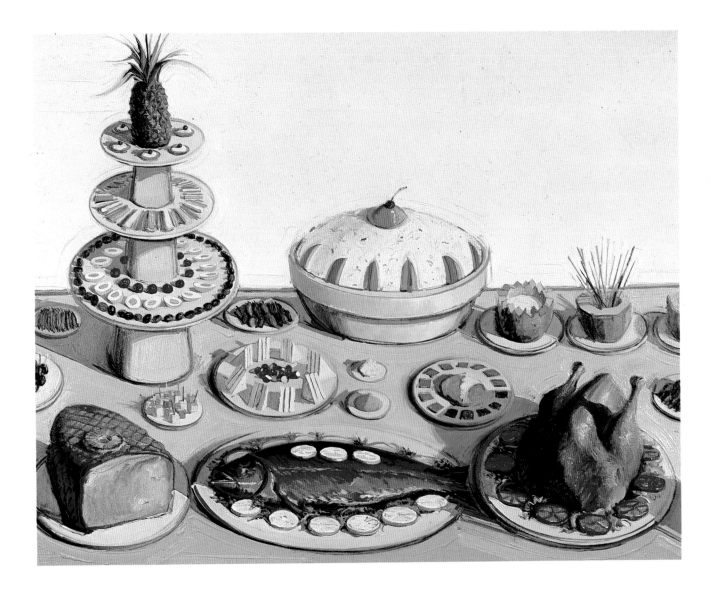

BUFFET—Wayne Thiebaud

Oh that my words were now written!
Oh that they were printed in a book! ~ Job 19:23

Certain things have always been most important to me. I would like to share some of them with you, both because I'd like you to understand the kind of person I have been and because some day you too may feel that they are important.

Give your ears to hear the sayings,
Give your heart to understand them.

—Amenemope— (11th Century B.C.)

Some members of our family were known
for their pet phrases, which could be funny or clever
or silly or wise. Here are a few of them and who
said them.

*Every tradition grows more venerable.... The reverence
due to it increases from generation to generation.*

—Friedrich Nietzsche (1844-1900)

Each family does certain things in its own
special manner. From the way we celebrate birth-
days and holidays to the kinds of food we eat,
traditions are an important means of tying us
together. Here are some traditions that I hope you
will continue.

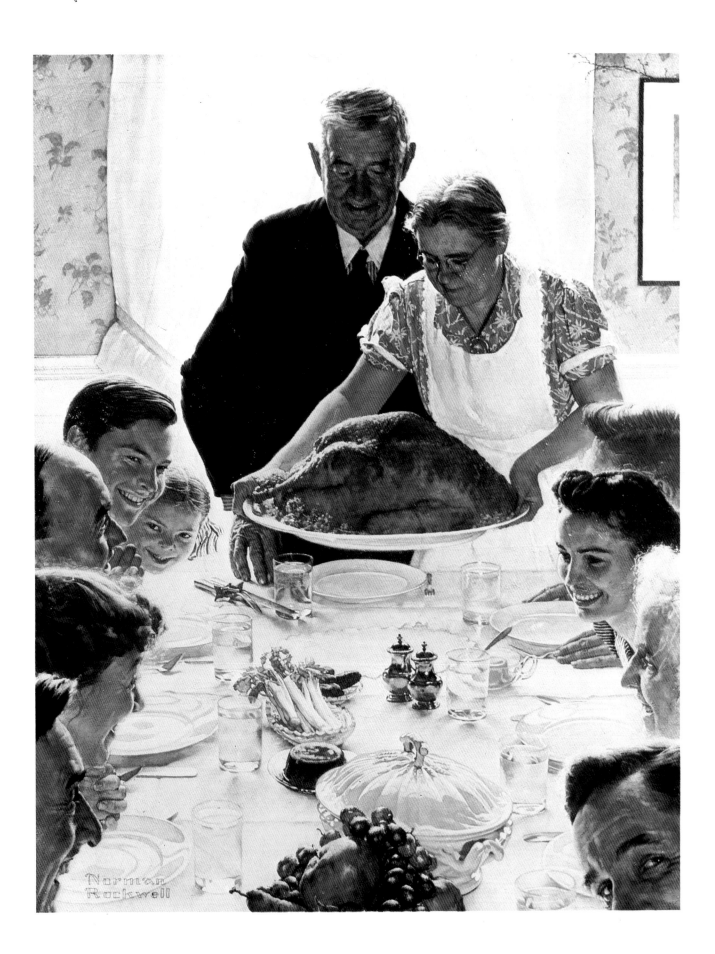

FREEDOM FROM WANT—Norman Rockwell

Kissing don't last: cookery do!
~ George Meredith (1828-1909)

Here are the recipes for a few of the dishes that were always requested when the family came to visit me.

Remember me when I am gone away,
Gone far away into the silent land.
— Christina Rossetti (1830-1894)

This book is one of the few things I can give you that no one else can. It is something special for someone who has always been special to me.

I hope it will answer questions about me and your family, as though I were with you.

Most of all, I hope it will serve as a memento that helps you to recall someone who will always love you very much.